Marcus Westberg

REMEMBERING LIONS

This book is dedicated to those who never give up trying to prevent the mass extinction of our wildlife. To the people on the frontline who risk and lose their lives, and to all who have contributed to *Remembering Lions* to help keep this iconic species alive for future generations. From our hearts we thank you, as without you, books like this could be all that's left of lions. We cannot let this happen.

VIVIEN JONES

Frans Lanting

For Minna,
Thank you for

REMEMBERING
LIONS

Wildlife Photographers United

Will Burrard-Lucas

CONTENTS

INTRODUCTION 7
Margot Raggett

FOREWORD 11
Jonathan & Angela Scott

A LION'S LIFE 12
Adam Bannister

LION DISTRIBUTION 16

REMEMBERING LIONS 19
The Photographs

LIVING WITH LIONS 128
Dr Amy Dickman

REMEMBERING CECIL 131
Brent Stapelkamp

AFTERWORD 133
Dr Luke Hunter

INDEX TO THE PHOTOGRAPHS 136

ACKNOWLEDGEMENTS 140

Sumeet Moghe

Asiatic lion, Gir Forest, India. From around only 20 in 1915, the recovery to the current population of around 650 animals including cubs is seen as a conservation success story in some eyes. But they are isolated and vulnerable to in-breeding, disease and natural disasters

INTRODUCTION

It is hard sometimes to imagine that the lion could possibly be in trouble. For most, lions are the top predator on any safari bucket list and looking at the stunning images we've been able to assemble in this book, it is not difficult to see why. From magnificent black-maned males whose majesty raises a tingle in the spine; to affectionate females and their comical cubs; they are a crowd-pleaser that excited tourists delight in sharing pictures of, perpetuating an impression that they remain happily numerous in Africa.

But make no mistake, in trouble they are. Their numbers are plummeting and in just the last quarter of a century, lion numbers have declined by half. From a historic almost-global footprint (millions of years ago they were on almost every continent), their range continues to shrink rapidly and is now confined to just sub-Saharan Africa and a small, isolated pocket in the Gir Forest in India. This particular Asiatic community – of around 650 animals including cubs – confined, in-bred and with no-where to go, is both poignantly and pointedly symbolic of the future lions in Africa might also face. That's if the current trajectory does not change. The question is, do we care?

When I started producing this book, I had no idea how complex the issues were. I knew lion numbers were dropping but I'd also heard, given the right circumstances, how quickly they can breed and rebuild numbers again. Add to that how rarely we see photographs of lions that have been killed (unlike the all too-prevalent images of poached elephants and rhinos) and the picture was confusing. Were lions really disappearing at all, when I could still so easily see them on a safari to the Maasai Mara?

As time has gone on however, and in speaking to many dedicated people working in the field across Africa, the reality has become much clearer. The threats are numerous and as ever in conservation, complicated.

The complication even starts with the fact that in reality, it is extremely difficult for anyone to know exactly how many lions there really are left in the wild. It is incredibly challenging for censuses to give accurate numbers and they are also often biased by the agenda of whoever has commissioned them. The most widely accepted figure is an estimated 20,000 lions left – substantially less than the estimated 30,000 rhinos and 400,000 elephants – which shocks many. The opportunity for variance on that is undoubted however, which allows some to bend the figures to their argument.

Ask most people on the streets of London what the biggest threat to lions is and particularly after the global media storm around the killing of Cecil the lion (which you can read more about later in this book), they'd probably answer hunting. Yet while it is true that likely hundreds of lions are killed each year through trophy hunting, and that poorly regulated and illegal hunts particularly can have catastrophic impacts on whole prides, this distasteful practice is now far from the biggest killer of lions in the way that it was in the past. As hunting on a prolific scale reduces, a new threat takes the lead.

The truth is, that it is estimated ten times more lions are now killed every year through conflict with humans than through hunting. With almost half of Africa's remaining lion range falling outside of protected areas, habitat loss is actually the biggest threat facing lions, but this commonly manifests itself in an increase in human-wildlife conflict. That's conflict with locals who we naively expect to live peacefully alongside the predators. And this is a conflict we find far harder to pin down and point a finger at, than the grotesquely celebratory hunters who fill our news feeds. Which is perhaps why it is far less discussed.

Again from the point of view of those on the streets of London, it is difficult to understand why anyone would want to kill something as iconic as a lion. But when your livelihood is your livestock and lions attack, or even heaven-forbid they attack your family, understandably they are seen as a pest to be removed, just as rats are viewed by western city-dwellers.

The result is extermination in both places. In the case of lions, this is often by spears but also increasingly through poisoning too, which has devastating ramifications for whole prides and also the wider ecosystem. Add to that ritualistic-killings, which are still practised in some places as a rite of passage; a continued illegal demand for and trade in body parts, bones and pelts; deaths and injuries through snares left for bush meat (see picture opposite); and rapid loss of habitat and it is a surprise there are any lions left at all. Indeed, in some places like West Africa, the numbers are already dangerously low. In others like North Africa, they are now completely gone and that's happened in living memory for some.

In the west, we recoil from this picture with disgust, but who are we to judge while we so readily eradicate the pests on our own doorstep without compunction? Could you live with a lion as a neighbour? Would you be tempted to snare if poverty meant it was the only way to feed your family?

And what of the vast stretches of land that are currently set aside for hunting, the popularity of which is undeniably – and to the great satisfaction of many – dropping? Campaigners fight every day for an end to this barbaric pastime and that tide does seem to be turning in their favour. But what's less spoken about is what will happen to that land when the hunters abandon it? With no alternative plan and finance in place to secure those areas for wildlife, it could well be converted to agricultural or even development use for an ever-expanding population. It almost certainly won't be a place that lions will be welcome. And long before that, poachers will have free reign to move in and kill far more 'trophies' than the hunters that went before.

Although this book largely focuses on wild lions and their plight, it would be remiss not to also mention the so-called 'blood-lions' captive trade, awareness of which was so effectively raised in the film of the same name. In that, an industry has emerged utilising purposely-bred lions at every stage of their life-cycle; from cubs unwittingly cared for by well-meaning yet exploited volunteers; to the hunters who want a quick and easy way to shoot a trophy; to the illegal but lucrative lion bone trade after they die (lion bones are now in demand to replace the traditional tiger bone trade, due to the scarcity of those). It is scarily efficient and ethically repugnant but while the demand remains, thousands of captive lions will continue to be bred for the profits it brings. These lions, whose numbers are not counted in the figure of 20,000, know nothing of a life in the wild, only exploitation and misery at the hands of man.

We live in an increasingly divided world it seems, one where conflicting views and demands often distract us, in my opinion, from the bigger picture. But I believe we can also take hope from it being a time in history where young campaigners such as Greta Thunberg are effectively and determinedly opening people's eyes. Encouragingly, and thanks to a new generation of activists, there is more awareness than ever about the catastrophe facing our planet if we don't rebalance our priorities. Profit, growth and greed simply cannot be the model we allow to continue to run the world.

Steve Winter

And I do not believe that wildlife can always be expected to pay for itself in the way many claim, because that model is simply unworkable in many places. It is therefore incumbent on us, before it is too late, to find alternative ways to finance its fundamental right to share this planet. To do that, we must persuade as many as we can to support that objective. We need to encourage not blame, unite with and listen to those with all viewpoints and understand our priorities are not always the same. We must realise that collective will is the only thing that will save the situation. I sincerely hope that the images in this book, generously donated by photographers who feel as passionately as me, will serve as a reminder of what we all stand to lose.

If we want to persuade and encourage those who live alongside lions to allow them to thrive, some sustainable value and rationale need to found for those people to do that. Because it is upon their shoulders we place the burden of whether lions will survive at all. What brings me hope is that it can be done. There are increasing numbers of places where land is being protected through philanthropy rather than profit. And I've seen for myself that when lion conservation leads to improved education, healthcare, food security and skills training, communities become true champions of wildlife presence.

Lions can recover quickly, and that recovery, if well-managed, can also lift local communities out of poverty. There is a way for everyone to win. There is hope.

MARGOT RAGGETT
Founder, Remembering Wildlife www.rememberingwildlife.com www.margotraggettphotography.com

Clement Kiragu

FOREWORD

"When fifty years from now a lion walks into the red dawn and roars resoundingly, it will mean something to people and quicken their hearts whether they are bolsheviks or democrats, or whether they speak English, German, Russian or Swahili. They will stand in quiet awe as, for the first time in their lives, they watch twenty thousand zebras wander across the endless plains." Dr Bernhard Grzimek (1959) *Serengeti Shall Not Die*

No other animal has fired the human imagination quite like the lion. The king of beasts is a universal icon embedded deep within our psyche. While the real lion faces a bleak future, their power to strike a chord with our emotions endures. Their fierce visage is immortalised worldwide from London to Beijing, emblazoned on national flags and crests of arms, cast in bronze and sculpted in marble, a potent symbol of the warrior spirit that we so admire even as they slip towards oblivion.

Most cats inhabit a twilight existence, whether lying in wait for prey or hiding from danger posed by predators and rivals. Gloriously self-sufficient, the cat is the quintessential lone hunter, relying on stealth and concealment, whether a 200kg Bengal tiger crouched among golden grass in Rajasthan or a tiny rusty-spotted cat. Often we don't realise the cat is there as it waits to strike or melt away unseen. Not so the lion. Lions appear to dominate the savannah, boldly announcing their presence. They are the only truly social member of the cat family.

What African safari would be complete without glimpsing a pride of lions sprawled in the shade of an acacia thicket? Watching as lionesses and their cubs wrestle with unbridled joy and abandonment momentarily masks the harsh reality of an existence ruled by the threat of violence. A tawny heap of bodies, legs akimbo, heavy heads resting on one another's rump, a floppy paw stretched across a midriff, the rise and fall of swollen stomachs filled with meat, long black-tipped tails flicking away tiresome biting flies. There is a palpable sense of plentitude when lions are seen in numbers. But there is poignancy too.

Lions were once the most widespread large mammal on Earth after humans. During the Pleistocene their mighty roars could be heard across much of Africa and the wooded landscapes of Europe. They prowled the dry steppes of Asia and grasslands of America where Panthera atrox – the largest lion that ever lived – preyed on American bison, mammoths, and other large hoofed mammals. Today lions are in the balance, their natural landscape reduced by 90 per cent in the past century with numbers dwindling at such an alarming rate that barely 20,000 remain.

The problem for the lion is that it needs large tracts of real estate providing shade and water, the same things that man covets. Lions are not alone in being under siege. Cats large and small are threatened by the burgeoning human population leading to loss of habitat and natural prey, increasingly bringing them into conflict with humans and livestock.

There can only be one winner in the scramble for our last wild places. We know how lions live and what we need to do to ensure their survival. There can be no excuses, only shame if we allow the most iconic big cat to disappear from our planet. *Remembering Lions* is a call to arms on behalf of the warrior king. We must act now if future generations are to enjoy the sound of wild lions roaring at dawn.

JONATHAN & ANGELA SCOTT
The Big Cat People www.bigcatpeople.com

A LION'S LIFE

The archetypal image of a lion is one of strength, courage and nobility. We elevate them in our admiration to supreme creatures; majestic beasts striding through savannahs with a roar as loud as thunder, that you can feel in your very soul. As a result however, few fully appreciate their vulnerability.

Lions are unique among cats in that they are social and live in groups called prides. At the heart of the pride are several generations of females and their cubs, accompanied by fewer, unrelated breeding males. This sociality was always believed to have been driven by cooperative hunting and communal rearing of cubs, but recent studies also suggest that it is driven by a need for joint defence of territory. Whatever the reasons for cooperation, lion prides are fiercely territorial, banding together to protect their area, which is usually dictated by high-quality hunting opportunities and dens. It is the sisterhood of females who 'own' the territory.

Success in life for both sexes depends on forming strong bonds with one another. Two or three adult males usually accompany a pride and are often related, though single males will try to join forces with non-relatives during the nomadic phase of their life. Coalitions of four or more males are almost always related however and such powerful alliances enjoy longer tenure and greater breeding success, often controlling more than one pride at a time. Regardless of relatedness, males patrol and defend their territory as fiercely as blood brothers. Lion society is mostly ruled by the threat of violence rather than its execution but inevitably the tenure of most males eventually comes to an end when new, younger males take over. Females on the other hand will try to stay in their natal pride for life, but with food and den sites at a premium, groups of younger females are sometimes forced to find a territory of their own.

A female lion has her first litter of cubs by around four years of age, breeding for the majority of her life. Gestation is around 110 days and an expectant mother becomes wary as she nears full term, removing herself from the pride a few days prior to birth. She mostly gives birth to between two and four cubs.

A lion cub is born completely helpless and blind. Tucked away in a den, the spotted cubs are totally dependent on their mother for survival. Dens can take on a number of forms from dense thickets, to rocky outcrops, all of which provide necessary cover and protection. The mother aims by isolating herself to protect the cubs in their vulnerable infancy but she is forced to leave her cubs to hunt. As a result, mortality rates are high (up to 50 per cent) with many cubs failing to reach adulthood due to starvation and threats such as hyenas through to buffalos.

Killing of cubs by new males – known as infanticide – is another major concern. When a coalition of males take over a pride, they will kill young cubs sired by previous males, bringing the females back in to breeding condition. Mothers do everything within their power however to protect their cubs, at times risking their lives. Often, females within a pride have synchronised breeding, enabling them to share responsibilities for the pride's cubs including fighting off incoming males. Lion cubs will suck at any teat (and any accepting mother).

Jonathan & Angela Scott

A mother and her cubs reintegrate into the pride after six to eight weeks, when she cautiously allows her offspring to meet their father – or fathers. Females will often have mated with more than one male within their pride to ensure that all the pride males accept the cubs as their own. It has been proven though that they 'prefer' to breed with males that have a black mane, which is considered a sign of fitness. Females are in estrus for four to five days, during which they mate with pride males every 10 to 30 minutes – up to 100 times a day – it is exhausting. Mating is fierce, primal and painful for the lioness, though this doesn't seem to stop her.

Like human families, lion prides have good and bad days. Physical contact, licking, grooming and nuzzling are essential in the bonding process as time together makes for an effective hunting and breeding unit. Under the watchful eye of the pride, new cubs slowly become integral in the pride's success. By two months of age, cubs will have tasted meat and at three to four months they are regularly brought to kills. At six or seven months they are fully weaned and at 11 months may contribute to hunts. It takes time for young lions to refine their ability to stalk, pounce and chase but they certainly practice endlessly and comically in their playtime, watched by their parents with a doleful eye. But by the time they are two, sub-adults are usually reasonably competent hunters.

Lions hunt a variety of animals and prey preference varies geographically. Some prides specialise in hunting particular species and each family has its own hunting culture. At this stage, the difference between males and females becomes evident not only in terms of size, strength and appearance, but also in social bonds, roles and behaviour. Females initiate most hunts, but males – who also hunt more than most realise – are often most crucial when a pride tackles larger prey such as buffalo, giraffe and even elephant. However, the key role of a male is to protect the pride by roaring, scent marking and patrolling to deter intruders.

Sub-adult males are forced out of their natal pride at two to three years of age to prevent in-breeding. Lonely young males then have to try to avoid conflict with other lions as they wander as nomads, reading scent messages left by territory holders and listening to their roars. But by the age of four, they are ready to challenge resident pride males for the chance to breed, driving out aged, injured or less powerful coalitions. And so the cycle goes on.

There is little that can compete with the majesty of a full-grown male lion; his roar reverberating across the savannah, his mane billowing in the breeze. But life is tough in the end even for the king of beasts. Most male lions eventually die a lonely and violent death, killed or injured in fights over territory, with 14 years being deemed a long life. Protected by the pride, lionesses however, can live up to 18 years.

Lions are warriors at heart and deep within their DNA lies a desire to control land, reproduce and bond both affectionately with one another, while also fiercely defending themselves. On a primal level, it is perhaps those traits that make them so enduringly alluring to humans.

ADAM BANNISTER
Ranger, Guide and Naturalist www.adambannisterwildlife.com

Suzi Eszterhas

LION DISTRIBUTION

RANGE
- HISTORICAL
- CURRENT

Scientific name:	*Panthera leo*	**Population:**	20,000–22,500
Range:	Angola, Benin, Botswana, Burkina Faso, Cameroon, Central African Republic, Chad, Democratic Republic of Congo, Ethiopia, India (Asiatic subspecies *P. l. persica* in Gir Forest only), Kenya, Malawi, Mozambique, Namibia, Niger, Nigeria, Rwanda, Senegal, Somalia, South Africa, South Sudan, Sudan, Tanzania, Uganda, Zambia, Zimbabwe	**Life-span:**	About 18 years (up to 25 years in captivity)
		Major threats:	Habitat loss; human-wildlife conflict; bushmeat snares for other species; trade in lion parts; trophy hunting in some places; disease; prey-base depletion; in-breeding
		IUCN status:	Vulnerable
		CITES:	Appendix II listing
Habitat:	Forest, grassland, shrubland, savannah, desert		

Todd Gustafson

In Ancient Assyria, hunting lions was a royal sport. The scene here – from a relief now housed at the British Museum – depicts one of King Ashurbanipal's spectacular public lion hunts. The hunt was staged so that Ashurbanipal, who ruled Assyria from 668-627 BC, was guaranteed to kill a significant number of lions

Once lions were almost everywhere. Spreading from East Africa – where fossils of the world's first lion-like cats, some three and a half million years old, have been found – into southern Europe, South Asia and the Middle East, lions had the most extensive distribution of any un-winged mammal, bar us, on Earth.

Africa was golden with lions. Tens of thousands lived in the north, in Egypt, Libya, Morocco and Tunisia, and many thousands more roamed the south. From the east in countries including Ethiopia, Djibouti and Rwanda, across to countries like Senegal, Nigeria and Ghana in the west, lions filled the continent, leaving only its most inhospitable, most life-defying regions unconquered. In the last century, though, lions in Africa have lost 75 per cent of their former territory and occupy just eight per cent of their former range.

Around Asia, lions also had a vast, wild kingdom – one that stretched from northern Greece into Albania, Bulgaria, Macedonia and Serbia, across to west Asia via Turkey, Saudi Arabia, Iran, Iraq, Syria and Oman, alongside outposts in Afghanistan, Bangladesh, India and Pakistan in south Asia. Today, only around 650 Asiatic lions (including cubs) survive in the Gir Forest in south-west India.

We now live in a world with precious few lions. No other species on Earth has lost so much of its ground, seen so much of its former territories shrink over historical times, as the lion has. In a very short space of time – the past hundred years or so – around 90 per cent of the world's lions just aren't here anymore.

SARA EVANS
Author of *When The Last Lion Roars* www.whenthelastlionroars.co.uk

The Chauvet-Pont-d'Arc Cave, Ardèche, France © J. Clottes / MC

FOUNDING SUPPORTERS

REMEMBERING LIONS would like to thank the following Founding Supporters whose generosity helped make this ambitious project a reality once again: Ben Carrick, Nancy Costolnick, Dave Cox, Vivien Jones, Camilla Legh and Peter Williams, Barbara Martin, Susan & Lynton McCurrach, Sharlene Rowling, Christo Schmidt, Julia & David Whitfield.

ALL OF THE IMAGES in this book have been generously donated by wildlife photographers who are united in their desire to celebrate and protect lions. We would like to thank each and every one of them, without whom this book would never have been possible.

REMEMBERING
LIONS

THE PHOTOGRAPHS

Melissa Groo

Kyle de Nobrega

Roy Toft

25

Hendri Venter

Shem Compion

27

James Gifford

Billy Dodson

Yaron Schmid

Jami Tarris

Sabine Bernert

Mark Dumbleton

Marsel van Oosten

Thomas D. Mangelsen

Art Wolfe

Daniel Rosengren

Theo Allofs

Pete Oxford

49

Heinrich Neumeyer

Kim Griffin

James Suter

Sabine Stols

Sarah Skinner

Andy Skinner

Morkel Erasmus

Lakshitha Karunarathna

Ross Couper

Federico Veronesi

Jan van der Greef

Anja Denker

Tanja Dekker

Chad Cocking

Marcus Westberg

Keith Connelly

Nelis Wolmarans

Tristan Dicks

Margot Raggett

Isak Pretorius

Karine Aigner

Amy Shutt

Marlon du Toit

Greg du Toit

Michael Poliza

Michael Lorentz

Adam Bannister

Phil McFadden

Todd Gustafson

Roger Hooper

Andy Biggs

Hilary Hann

Chris Schmid

Chris Packham

Marius Coetzee

Paul Goldstein

David Lloyd

Piper Mackay

Daryl & Sharna Balfour

Richard Peters

Albie Venter

Paul Joynson-Hicks

Andrew Aveley

Hannes Lochner

Tom Way

Daniel Bailey

LIVING WITH LIONS

Flying into Africa for the first time, more than 20 years ago, marked the culmination of a life-long fascination with big cats. Until then, I had made do with endless hours at the zoo, poring over books or immersing myself in wildlife films. Everything I had seen reinforced my admiration of these supremely powerful and beautiful top predators that represent the very epitome of wilderness. Peering out of the aeroplane window, I was amazed to think there really were lions down in that immense dusty savannah. I stared out for hours, squinting for any hint of wildlife as the African landscape unfurled and changed far beneath me. Shockingly to me now, never once did I consider the human populations inhabiting that vast continent – I was completed fixated on the big cats I had come to research.

My focus was slow to change – usually I only thought of local people in terms of threats posed to big cats. Caring for big cats injured in traps, or cubs whose mothers had been shot, made it hard to change my views. Over time, however, my awareness grew of what it really means to live alongside these predators.

One memorable night in the Tanzanian bush, a huge male lion approached my tiny tent, lay down on me and slept for hours. My predominant emotion was breathtaking terror, desperately aware I had no protection against this beautiful but deadly large carnivore. After establishing the Ruaha Carnivore Project in Tanzania, I spent time within rural villages and started to recognise the true costs of living alongside big cats. I hated seeing the desperation in someone's eyes after a lion had killed one of their few cattle, particularly when I came to realise the true social as well as economic value that livestock had to these very poor communities. It was terrible hearing the grief and desolation from people whose relatives had been killed by lions while doing nothing more than walking home through the bush. Realising that wildlife I valued so much had devastating impacts on local people made me feel uncomfortably guilty. Much as I was committed to conservation, I did not want to be part of something that ignored or exacerbated those impacts. Although people here had lived alongside lions for generations, it was not an easy coexistence, and they usually valued dead lions above live ones. Conservation was largely seen as something alien, exclusive and imposed by rich outsiders. Realising all these factors, it seemed impossible that with Africa's rapidly growing human populations, there could be any long-term conservation without true buy-in from people living alongside big cats.

That became the foundation of our project; that conservation should be driven locally, with us helping to leverage the international value of big cats to engage, empower and uplift local communities. It was not new – many projects, such as those in the Lion Conservation Pride Alliance, have been built on that very approach. People in the west often fear the rapid growth in Africa's human populations, but if we show that wildlife conservation not only fits in with development, but can also drive it, then those people will be the most effective ambassadors for lion protection for generations to come. Today, in Ruaha, I am so proud when I see that our project has improved local healthcare, education and livelihoods, and because of that, the wildlife is more valued and more secure. I am still as fascinated by big cats as ever, but now I know that only by valuing both people and wildlife will we have a future where lions are protected as true global treasures.

DR AMY DICKMAN

Director, Ruaha Carnivore Project, Tanzania www.ruahacarnivoreproject.com

African People & Wildlife / Felipe Rodriguez

Life alongside lions helped by 'A Living Wall' – an environmentally friendly corral designed by African People & Wildlife in partnership with the Maasai people – which conserves lions by securing livestock in northern Tanzania

Brent Stapelkamp

Cecil (front) and his coalition partner Jericho (rear) in Hwange National Park, 2015

REMEMBERING CECIL

Perhaps the most famous lion who ever lived, 'Cecil' was a black-maned male lion killed illegally in Zimbabwe by a hunter called Walter Palmer by bow and arrow in 2015. The outrage that followed his death was unprecedented and shone a spotlight on trophy hunting like never before.

Despite the arguments put forward by the hunting industry, it is undeniable that illegal hunts such as this have devastating ramifications. Brent Stapelkamp, the researcher in charge of tracking Cecil's GPS collar data, blew the whistle on the hunt and became the focus for the world media's attention. Here he recalls those few days.

People ask, "why Cecil?" Why was this story so huge? And I say that it comes as no surprise that the world reacted to this story like it did. It was after all about a lion, our most majestic animal and one that we revere and celebrate like no other. To that, add an antagonist – a dentist of all people – whom out of selfish egotistical reasons took from this world one of the most iconic individuals from the most iconic species, a species fast disappearing. That resonated with us because it is a metaphor for our current relationship with this planet.

I knew Cecil and about 200 other lions intimately. I was a lion researcher in Hwange National Park and my job, alongside watching and spending time with them, was to dart and collar them. Although I specialised in conflict-mitigation work outside of the park, I also monitored several lion prides for the ecological study. Cecil never knew me of course, but I knew him. I spent hundreds of hours with him and his pride. He was a wonderful subject to photograph and study because he was so confident and relaxed.

One day, Cecil's collar didn't send me any data. I thought the collar had failed, so planned to catch him when I saw him next. But two days later a guide told me, in whispers, of a lion hunt in that area. There were no hunting permits in issue at that time, so my heart literally stopped. I gave the authorities Cecil's last GPS point but expected apathy like the last dozen such hunts. How wrong was I? If a hurricane starts on the wings of a butterfly, this typhoon started at the very tip of an American dentist's arrow.

After a couple of weeks of behind-the-scenes agitation, the story broke and the world's press descended on me. At first, I was commended by both the authorities and my employers for keeping it together in such trying circumstances, but soon various vested interests had started applying pressure and the river of donations was drying up. I was told to "shut up".

I attended meetings where I was accused of profiteering from the Cecil story while leaving the hunting industry in ruins and was threatened to a point where I slept with my rifle nearby. It was a terrible time for my family and me, but this was our chance – our one and only chance – to speak up for lions.

The world's most iconic species and one of man's oldest companions is in dire straits and trophy hunting is undoubtedly, in my mind, a significant contributor to that decline. The repercussions after a lion is hunted are felt for many months after the skin and skull are shipped to a living room in the USA somewhere, with cubs killed, lionesses abandoning territories and killing livestock and young males leaving prides early. Communities suffer, lions suffer, tourism suffers and all the while, the hunter sleeps easy believing he is conserving lions.

I had to speak out, for Cecil's sake. Cecil never knew me of course, but I knew him. And I remember him.

BRENT STAPELKAMP
Co-founder, The Soft Foot Alliance www.softfootalliance.org

Suhail Manji

AFTERWORD

A young male lion rests on a mound of earth, scanning the surrounding savannah from his elevated vantage. He is watchful for prey but it is daylight, hunting is not particularly on his mind. He is more focused on spotting other lions; his coalition mates with whom he shares a lifetime bond, the pride lionesses that share his territory and birth his cubs and, always at the back of his mind, rival males that could kill him or his offspring. It is an iconic image of Africa.

And there is a city of 6.5 million people behind him.

Nairobi National Park is a microcosm of the challenges facing the lion. Hemmed in on three sides by Nairobi's sprawling development and on the fourth by agriculture and livestock, the reserve is an island. Lions leaving the park's protection invariably clash with people, and are almost always killed if they stay outside. At only 117 km², the protected area will never hold more than three or four prides, around 30 lions. The same threats – rapid development that converts habitat and extirpates prey, conflict with pastoralists, isolation in fragments of former range – confront the lion across much of the continent.

Yet looking at this picture gives me hope. In it, I see the future of Africa's humanity. An increasingly affluent and urbanised one, in which people abandon remote and often impoverished rural areas to seek better prospects for themselves and their children in cities. Elsewhere around the globe, rural depopulation and the nature-loving constituency that emerges in urban populations has created space for the recovery of wilderness and the large carnivores that rely on it. In the USA, it has allowed wolves, grizzly bears and mountain lions to expand beyond small, post-World War II refugia to reoccupy much of their original ranges. In western Europe, Eurasian lynxes, bears and wolves now live in restored forests rich in native ungulate prey, both of which had almost vanished to fuel the economic expansion of the last century.

The same socio-economic uprising is now transforming much of Africa. And, unlike much of Europe and North America during their transformation, sub-Saharan Africa still has staggeringly large and mostly intact protected areas. The Central Kalahari Game Reserve in Botswana is larger than Denmark or Costa Rica. South Africa's Kruger National Park is the size of Israel. While they face their own set of tremendous pressures, size translates to resilience. That such massive, protected wildernesses prevail in Africa, just as the continent embarks on its urbanising revolution, reassures me that lions will also prevail.

The lion will prevail. Not only in tiny, isolated patches like Nairobi National Park but in vast, functioning, wild ecosystems. The apex carnivore at the centre of innumerable complex interactions among uncountable wild creatures. It will not be easy. It will require a mammoth escalation of conservation effort and, crucially, a much improved commitment of funding from the global community. But Africa and its lions are nothing if not resilient. The lion will prevail.

DR LUKE HUNTER
Carnivore Conservation Biologist and Author

SUPPORTING REMEMBERING LIONS

We are constantly taken aback and deeply moved by the kindness and encouragement of so many amazing supporters of our project.

This year, *Remembering Lions* would not have been possible without the generous and unhesitant sponsorship of the following wonderful individuals and organisations who stepped in, in lieu of a corporate sponsor.

Andrea and Arielle Gonzalez

Barbara Martin

Olsen Animal Trust

Richard & Lynda Leonard

Vivien Jones

We are eternally grateful to each of them for enabling us to turn our vision into a beautiful book, with the collective aim of securing a future where our grandchildren can live in a world in which lions continue to roam in the wild.

Marlon du Toit

INDEX TO PHOTOGRAPHS

Front cover
Federico Veronesi, Kenya / Italy
www.federicoveronesi.com
Serengeti National Park, Tanzania

p2
Frans Lanting, The Netherlands
lanting.com
Okavango Delta, Botswana

p4
Will Burrard-Lucas, UK
www.burrard-lucas.com
Katavi National Park, Tanzania

p6
Sumeet Moghe, India
www.instagram.com/sumeet_moghe
Gir Forest National Park, Gujarat, India

p9
Steve Winter, USA
www.stevewinterphoto.com
Queen Elizabeth National Park, Uganda

p10
Clement Kiragu, Kenya
www.clementwild.com
Maasai Mara National Reserve, Kenya

p13
Jonathan & Angela Scott, UK / Kenya
www.bigcatpeople.com
Maasai Mara National Reserve, Kenya

p15
Suzi Eszterhas, USA
www.suzieszterhas.com
Maasai Mara National Reserve, Kenya

p21
Melissa Groo, USA
www.melissagroo.com
Serengeti National Park, Tanzania

p22-23
Kyle de Nobrega, South Africa
www.kyledenobrega.com
Mana Pools National Park, Zimbabwe

P24-25
Roy Toft, USA
www.toftphoto.com
Okavango Delta, Botswana

p26
Hendri Venter, South Africa
www.instagram.com/hendriventer
Kruger National Park, South Africa

p27
Shem Compion, South Africa
www.shemimages.com
Mashatu Game Reserve, Botswana

p28-29
James Gifford, UK
www.jamesgifford.co.uk
Savute, Chobe National Park, Botswana

p30-31
Billy Dodson, USA
www.savannaimages.com
Maasai Mara National Reserve, Kenya

p32-33
Yaron Schmid, Israel
www.yswildlifephotography.com
Serengeti National Park, Tanzania

p34
Jami Tarris, USA
www.jamitarris.com
Nxai Pan, Botswana

p35
Sabine Bernert, France
www.sabinebernert.fr
Maasai Mara National Reserve, Kenya

136

p36-37
Mark Dumbleton, South Africa
www.markdumbleton.com
Maasai Mara National Reserve, Kenya

p38-39
Marsel van Oosten, The Netherlands
www.squiver.com
South Luangwa National Park, Zambia

p40-41
Thomas D. Mangelsen, USA
www.mangelsen.com
Ngorongoro Conservation Area, Tanzania

p42-43
Art Wolfe, USA
www.artwolfe.com
Serengeti National Park, Tanzania

p44-45
Daniel Rosengren, Sweden
www.danielrosengren.se
Serengeti National Park, Tanzania

p46-47
Theo Allofs, Germany
www.theoallofs.com
Ndutu, Ngorongoro Conservation Area, Tanzania

p48-49
Pete Oxford, UK
www.peteoxfordexpeditions.com
Okavango Delta, Botswana

p51
Heinrich Neumeyer, South Africa
www.facebook.com/heinrichneumeyerwildlifephotography
Pilanesberg National Park, North West Province, South Africa

p52-53
Kim Griffin, USA
www.kimgriffinphotography.com
Maasai Mara National Reserve, Kenya

p54
Sabine Stols, Germany / Botswana
www.facebook.com/sabine.pangolinphoto
Maasai Mara National Reserve, Kenya

p55
James Suter, South Africa
www.blackbeanproductions.com
Chief's Island, Okavango Delta, Botswana

p56
Sarah Skinner, UK
www.imagesofwildlife.co.uk
Savuti, Chobe National Park, Botswana

p57
Andy Skinner, UK
www.imagesofwildlife.co.uk
Maasai Mara National Reserve, Kenya

p58-59
Morkel Erasmus, South Africa
www.morkelerasmus.com
Etosha National Park, Namibia

p60-61
Lakshitha Karunarathna, Sri Lanka
www.lakshithak.com
Maasai Mara National Reserve, Kenya

p63
Ross Couper, South Africa
www.rosscouper.com
Singita Sabi Sand, South Africa

p64-65
Federico Veronesi, Kenya / Italy
www.federicoveronesi.com
Maasai Mara National Reserve, Kenya

p66-67
Jan van der Greef, The Netherlands
www.janvandergreef.com
Kgalagadi Transfrontier Park, South Africa

p68-69
Anja Denker, Namibia
www.instagram.com/wild.anjadenker
Etosha National Park, Namibia

p70-71
Tanja Dekker, The Netherlands
www.wildpicha.com
Skeleton Coast National Park, Namibia

p72-73
Chad Cocking, South Africa
www.instagram.com/chadcocking
Timbavati Private Nature Reserve, South Africa

p74
Marcus Westberg, Sweden
www.lifethroughalens.com
Kafue National Park, Zambia

p75
Keith Connelly, South Africa
safaributler.com
Etosha National Park, Namibia

p76
Nelis Wolmarans, South Africa
www.neliswolmarans.com
Manyoni Private Game Reserve, KwaZulu-Natal, South Africa

p77
Tristan Dicks, South Africa
www.tristandicks.com
Sabi Sand Game Reserve, South Africa

p78-79
Margot Raggett, UK
www.margotraggettphotography.com
Maasai Mara National Reserve, Kenya

p80
Isak Pretorius, South Africa
www.theafricanphotographer.com
South Luangwa National Park, Zambia

p81
Karine Aigner, USA
www.karineaigner.com
Ngorongoro Crater, Tanzania

p82-83
Amy Shutt, USA
www.amyshutt.com
Maasai Mara National Reserve, Kenya

p84-85
Marlon du Toit, South Africa
www.marlondutoit.com
Maasai Mara National Reserve, Kenya

p86-87
Greg du Toit, South Africa
www.gregdutoit.com
South Rift Valley, Kenya

p88-89
Michael Poliza, Germany
www.michaelpoliza.com
Maasai Mara National Reserve, Kenya

p90
Michael Lorentz, South Africa
www.instagram.com/mlorentz23
Zakouma National Park, Chad

p91
Adam Bannister, South Africa
www.adambannisterwildlife.com
Londolozi Game Reserve, Sabi Sand, South Africa

p92-93
Phil McFadden, Australia
philmcfadden.smugmug.com
Ndutu, Ngorongoro Conservation Area, Tanzania

p94-95
Todd Gustafson, USA
totheendsoftheearthllc.org
Ngorongoro Crater, Tanzania

p96-97
Roger Hooper, UK
www.rogerhooper.co.uk
South Luangwa National Park, Zambia

p98-99
Andy Biggs, USA
www.andybiggs.com
Okavango Delta, Botswana

p100-101
Hilary Hann, Australia
www.hilaryhann.com.au
Lake Nakuru National Park, Kenya

p102-103
Chris Schmid, Switzerland
www.schmidchris.com
Serengeti National Park, Tanzania

p104-105
Chris Packham CBE, UK
www.chrispackham.co.uk
The Karoo, South Africa

p106
Marius Coetzee, Mauritius
www.oryxphotography.com
Maasai Mara National Reserve, Kenya

p107
Paul Goldstein, UK
www.paulgoldstein.co.uk
Olare Conservancy, Kenya

p108-109
David Lloyd, New Zealand / UK
davidlloyd.net
Maasai Mara National Reserve, Kenya

p110-111
Piper Mackay, USA / Kenya
www.pipermackayphotography.com
Serengeti National Park, Tanzania

p112-113
Daryl & Sharna Balfour, South Africa
www.wildphotossafaris.com
Maasai Mara National Reserve, Kenya

p115
Richard Peters, UK
www.richardpeters.co.uk
Maasai Mara National Reserve, Kenya

p116-117
Albie Venter, South Africa
www.africa-unlocked.com
Serengeti National Park, Tanzania

p118-119
Paul Joynson-Hicks MBE, Tanzania
www.pjhicks.photo
Maasai Mara National Reserve, Kenya

p120-121
Andrew Aveley, South Africa
www.andrewaveley.co.za
Kgalagadi Transfrontier Park, Botswana

p122-123
Hannes Lochner, South Africa
www.hanneslochner.com
Kgalagadi Transfrontier Park, Kalahari, South Africa

p124-125
Tom Way, UK
www.tomwayphotography.co.uk
Maasai Mara National Reserve, Kenya

p127
Daniel Bailey, South Africa
www.facebook.com/daniel.bailey.37853
MalaMala Game Reserve, South Africa

p130
Brent Stapelkamp, Zimbabwe
www.softfootalliance.org
Hwange National Park, Zimbabwe

p132
Suhail Manji, Kenya
www.instagram.com/sam_wildlife_photography
Nairobi National Park, Kenya

p134-135
Marlon du Toit, South Africa
www.marlondutoit.com
Maasai Mara National Reserve, Kenya

p144
Patrick Bentley, Zambia
www.patrickbentley.com
South Luangwa National Park, Zambia

Back cover
Andy Rouse, UK
www.instagram.com/wildmanrouse
Maasai Mara National Reserve, Kenya

ACKNOWLEDGEMENTS

As ever, I continue to find the enthusiasm and support for the *Remembering Wildlife* project completely overwhelming and also deeply moving. I am constantly amazed that there are so many people offering to lend their help and whatever skills they have to further the cause. So while I try and mention as many as I can here, if there is anyone I've missed who has helped in some way, please know I thank you too and that also goes to everyone who generously supported our Kickstarter!

I must start with my editorial team which this year comprises Lorna Dockerill, Eddie Ephraums and Andrew Nadolski. Our six month production process is a hugely complicated jigsaw puzzle and I could not produce such a beautiful book without the steadfast support of this team. I am also deeply grateful to the many working in lion conservation who have helped us enormously with this year's content, including Amy Dickman, Amy Hinks, Sara Evans, Luke Hunter, Brent Stapelkamp, Guy Western, Sam du Toit, Laly Lichtenfeld, Laura Milton, Sam Page-Nicholson and Ashley Robson.

I am particularly indebted to Victoria Petley this year, who has truly become my right hand woman in all aspects of the project! I'm also thrilled to welcome on board Greg Broadbent as our finance director for Remembering Wildlife Ltd, as we are now set up. Greg oversees all aspects of our finances now, challenging me and ensuring we maximise the profits, which are then donated on to projects. On that front I'd like to thank Greg du Toit, Isak Pretorius, Sue Olsen, Daryl Balfour and Jonathan & Angela Scott for their thoughts and contacts regarding projects to support. And on a wider point I must also single out Sue for her endlessly generous support and encouragement, along with her team.

Thank you to everyone who helped us with items and safaris to sell on Kickstarter. These include this year artists Karen Laurence-Rowe, Emily Lamb, Karen Phillips, Gary Hodges and our ongoing jeweller partners GIN Jewellery (thank you so much Graham and Tina). Also thanks to Suzi Eszterhas, Andy Biggs, Todd Gustafson and Roy Toft who allowed Graham to use their images as references. And thanks too to the photographers who donated prints for the Kickstarter this year – Daryl & Sharna Balfour, Andy Rouse, Federico Veronesi, Tom Way, Sarah & Andy Skinner, as well as Rob Cottle for approaching Olympus for their generous donation. I must also thank wildlife artist Simon Max Bannister and Kate Wilson of Mulberry Mongoose for pieces they'll be producing for our autumn auction, as well as Karen Laurence-Rowe!

I continue to be immensely indebted to Jonathan & Angela Scott. Not only have they contributed the foreword for this book, but they've also provided feedback and pushback on all aspects of the content for which I am more grateful than I can say. I must also mention this year Adam Bannister, who has been another huge help, acting as a sounding board and contributor to all aspects of the project. He has been a veritable fountain of ideas and contacts, and has willingly and freely given his time to help take much-needed images and video of our work. Thank you for becoming part of the team Adam, long may it continue in the future!

Adam's employer, Angama Mara, has also been a huge support, as have other long-term operator allies and friends to the project like Entim Mara, Nomad Tanzania, The Ol Pejeta Safari Cottages, Pangolin Photo Safaris and The Mantis Group and they've also been joined this year by the wonderful Bushcamp Company in Zambia, and Shompole Wilderness in Kenya. They have all generously donated stays to help us raise funds. To all of the owners of those businesses who believe in what we're doing and care so deeply about the wildlife we're all trying to protect – I salute you.

Projects across Africa work hard to mitigate the threats to lions. Here, David Aruasa, Head of Tourism for the Mara Triangle in Kenya shows Margot Raggett snares for bushmeat that have been removed from the area. Snares are indiscriminate in what they kill and in many areas they are the biggest threat of all to lions

Photograph: Adam Bannister

And then of course there are the contributing photographers to the book, without whom we would have nothing. As the project has grown we've now had work donated by more than 150 wildlife photographers – so to all of our alumni of Wildlife Photographers United, whether with an image in this or past books – please be aware just how great your contribution has been. We cannot do this without you. Thank you also to this year's competition judges Marsel van Oosten, Jan van der Greef and Niall Hampton of *Digital Camera Magazine* for their time and expertise.

To my huge friends and tireless supporters Kym Wilson and Sean O'Byrne, I continue to be filled with emotion over the support you give me each year. I am so truly very grateful for the love you show me, and also the project. And I must also thank this year Vladimir Cech Senior and Jnr (father and son), as well as Pim Volkers, who have all taken it on their own backs to produce campaigns in their own countries to promote the book – thank you.

Other individuals and organisations who I must also mention for their help and advice this year include Anne Tudor, Abagail Gardiner, Michael Lorentz, James Suter, Michael Eleftheriades, Rob Osmond, Sophie Kelly, Shem Compion and C4 Photo Safaris, Rachel McClelland of The Planet Shine, Simon Jones, Ofir Drori, Winnie Kiiru, Richard Peters, Rose Lewis, Jackie Downey, Rachel Pereira, Dan Richardson, Roger Hooper, Paul Goldstein, Nick Giles, Stephen Pocock, Colin Bell, Don Pinnock, Peter Borchert, Chris Packham, Will Burrard-Lucas, Helen Barnett, Lisa James, Arnold Temple, the Mara Triangle, Dave Mascall, Diana Bell Miller, the Anne Kent Taylor Foundation, the Zambian Carnivore Programme, SORALO, Tyler Davis, Steve Mitchell, Shannon Wild and Russell MacLaughlin, CBL, EBS, Naked Wines, by word of mouth and Genesis Imaging.

Additionally, I would also like to extend my huge gratitude to Barbara Martin, Christian Gonzalez, the Olsen Animal Trust, Richard & Lynda Leonard of Medivet and Vivien Jones – all of whom clubbed together to provide sponsorship of this year's book. Such an incredible gesture!

Lastly I'd like to finish by thanking this year all of the members of 'Team Wildlife' – our incredible and ever-growing band of enthusiastic volunteers. From stepping up to help with all of our events, to becoming super-fans on social media, they are an unstoppable force. Truly these books are a team effort and as we go over more than half a million pounds raised for conservation by their publication, I think quite simply that everyone involved in whatever way deserves a massive pat on the back. Thank you all!

MARGOT RAGGETT
Founder, Remembering Wildlife www.rememberingwildlife.com

SUPPORTERS

Remembering Lions would like to thank the following Supporters for their generosity:

Elizabeth Antell	Mandy Ferguson	Cathie & Laurie Petley
Anna Anthony	Christopher & Karin Agius Ferrante	Lisa Poncet
Isabel & Jack Bacon	Cathryn Gabor	Louise & Simon Potts
Berkett family	Dianne Harrison	Michael & Camilla Reyner
Mr & Mrs S Burrard-Lucas	Andy Howe and Austin Thomas	David Andrew Rowley
Serene Chew and Lina Othman	Ping Hung	Peter Sweet
Christine M Chudy	Mercedes Yvette Ll. Lopez	Brogan Vail
John & Claire Coleman	Sharon Loudon	Ray Varney
Simon Cox	Griet Van Malderen	Alison & John Woolcock
Andrew Crowther	Justine Morgan	Susan Woolias
Tanja & Willem Dekker	Jacqueline R. Nichols	Adam Zdebel
Adriana van Dongen	Tara & Jerry Overton	Michel C. Zoghzoghi

Second edition published 2021 by Remembering Wildlife Ltd

Copyright © Remembering Wildlife

Remembering Wildlife has asserted its right to be identified as the author of this work as in accordance with the Copyright, Designs and Patents Act 1988

All rights reserved. No part of this book may be reproduced or utilised in any form or by any means, electronic or mechanical, including photocopying, recording or by any information storage and retrieval system, without permission in writing from Remembering Wildlife Ltd

A catalogue record for this book is available from the British Library

ISBN 978-1-9996433-1-7

Remembering Lions
Author: Remembering Wildlife / Margot Raggett
www.rememberingwildlife.com, www.margotraggettphotography.com

Foreword: Jonathan & Angela Scott
The Big Cat People www.bigcatpeople.com

Editor: Lorna Dockerill
www.lornadockerill.com

Conservation data courtesy of IUCN Red List and the Wildlife Conservation Research Unit, University of Oxford

Designers: Eddie Ephraums & Andrew Nadolski

Production: Eddie Ephraums, Envisage Books
www.envisagebooks.com

Printed and bound by EBS, Verona, Italy

ALL profits from the sale of this book are donated to projects working to protect lions in the wild. Read more at www.rememberingwildlife.com

Patrick Bentley